THE LITTLE PRINCE

Inua Ellams

THE LITTLE PRINCE

OBERON BOOKS
LONDON

WWW.OBERONBOOKS.COM

First published in 2020 by Oberon Books Ltd
521 Caledonian Road, London N7 9RH
Tel: +44 (0) 20 7607 3637 / Fax: +44 (0) 20 7607 3629
e-mail: info@oberonbooks.com
www.oberonbooks.com

PB ISBN: 9781786828705
E ISBN: 9781786828712

Cover image: Inua Ellams
Title treatment: Carolyne Hill

Visit www.oberonbooks.com to read more about all our books and to buy them. You will
also find features, author interviews and news of any author events, and you can sign up for
e-newsletters and be the first to hear about our new releases.

Printed on FSC® accredited paper

10 9 8 7 6 5 4 3 2 1

Fuel produces an adventurous, playful and significant programme of work – live, digital, and across art forms – for a large and representative audience across the UK and beyond. They collaborate with outstanding artists with fresh perspectives and approaches who seek to explore our place in the world, expose our fears, understand our hopes for the future, create experiences which change us and in turn empower us to make change in the world around us. Led by Kate McGrath, Fuel is supported by Arts Council England as a National Portfolio Organisation, Esmee Fairbairn Foundation, and the Wellcome Trust through Sustaining Excellence. Kate McGrath and Inua Ellams met in 2008, after Kate saw the beginnings of what would become Inua's first play at Battersea Arts Centre. Fuel helped Inua Ellams develop this debut and produced it, premiering *The 14th Tale* at the Edinburgh Festival, winning a Fringe First, touring it in the UK and internationally and presenting it at the National Theatre. Since that first meeting Fuel has worked closely with Ellams, producing *Untitled*, *Knight Watch*, *The Long Song Goodbye*, *Black T-shirt Collection*, *The Spalding Suite*, *Barber Shop Chronicles*, *The Half God of Rainfall* and recently *Three Sisters*. Other current Fuel shows include *Three Sisters* (Inua Ellams, a coproduction with the National Theatre), *Touching The Void* (David Greig/Tom Morris), *The Day I Fell Into A Book* (Lewis Gibson), and *To Those Born Later* (Uninvited Guests).

fueltheatre.com / @fueltheatre

"Fuel is an inspiration" **The Guardian**

Registered Charity No: 1149680
Registered as a company limited by guarantee in England: 7935786

The Little Prince was first performed at Stratford Circus Arts Centre on 17 January 2020, with the following cast and creative team.

CAST

Sarah Cullum
Phoenix Edwards
Rebecca Layoo
Andrea Matthea-Laing
Joyce Omotola

Adapted by	Inua Ellams
Director	Femi Elufowoju, jr.
Designer	Miriam Nabarro
Lighting Designer	Neill Brinkworth
Movement Director	Kemi Durosinmi
Composer	Cassie Kinoshi
Sound Designer	Lewis Gibson
Puppet Designer	Nick Barnes
Puppet Director	Laura Cubitt
Casting Director	Nadine Rennie CDG
Dramaturg	David Greig
Company Stage Manager	Lynsey Fraser
Technical Stage Manager	Oran O'Neill

Production Management by The Production Family

Produced by Fuel, in association with English Touring Theatre.

Co-commissioned by Fuel, Stratford Circus Arts Centre, ASU Gammage, Z-arts, The Albany, Warwick Arts Centre, and Future Arts Centres. Supported using public funding by Arts Council England, the Royal Victoria Hall Foundation, the Golsoncott Foundation and the Garrick Trust.

This is an Afrofuturist adaptation of the much loved story by Antoine de Saint-Exupéry.

Afrofuturism (coined by Mark Dery in 1994) is a cultural aesthetic, philosophy of science, and philosophy of history that explores the developing intersection of African Diaspora culture with technology. It employs science fiction, fantasy, magical realism, horror, cosmology, myths, legends, spiritual practices and technoculture to re-contextualise African history, and imagine a future where people of African heritage are in charge of their own destinies.

Afrofuturism grew from the necessity for the African Diaspora to connect their future to their past. Strictly speaking then, as this adaptation originates from an indigenous African, this is *African-futurism.*

Characters

THE LP / Zekotan, galactic traveller, seeking to stop disaster.

GRIOT1 / Zekotan, leader of the storytellers.

GRIOT2 / Zekotan, storyteller.

GRIOT3 / Zekotan, storyteller.

AMULET / Zekotan, high-tech gizmo.

PILOT / Earthling, on her way to bomb an African country

FOX / Earthling, climate change activist.

SNAKE / Earthling, hipster and Apothecarist.

SULTAN / Zekotan, leader of the Hausa.

SULTANA / Zekotan, leader of the Fulani.

WM / Masquerade/Caricature of War and Military.

MN / Masquerade/Caricature of Mirrors and Narcissism

DD / Masquerade/Caricature of Drunkenness and Despair.

BM / Masquerade/Caricature of Business and Capitalism.

LL / Masquerade/Caricature of Lamplighting and Ignorance.

GA / Masquerade/Caricature of Geography and Administration.

Act One

Alkebulan Galaxy, Kanuri solar system, planet Zekoto, southern territory, the court in the sultan's palace. A huge baobab tree is in the centre, there are hi-tech-huts in the outer perimeter. The art, architecture and culture is inspired by those of the Hausa-Fulani peoples of northern Nigeria. There are airbikes that resemble horses, Arabic calligraphic sculptures, scooters and skateboards, a space-age village.

The GRIOTS take the stage carrying storytelling objects: planets, an amulet, a fighter jet and a small blue light. Around them, moon bugz, amulets and robopets whizz and fly by.

GRIOT1: Oh no! There are more!

GRIOT2: What do they want?

GRIOT3: To hear the story, I think.

GRIOT2: But we just finished!

GRIOT3: It's a new bunch.

GRIOT2: Maybe if we close our eyes they'll go away?

GRIOT3: Let's try.

 GRIOT2 & GRIOT3 close and open their eyes.

GRIOT2: They are still here.

GRIOT1: Are you sure they want to hear the story?

GRIOT2: I don't know. You ask!

GRIOT3: No you ask!

GRIOT2: No you ask!

GRIOT3: No you ask!

GRIOT2: No you ask!

GRIOT1: Walahi, if one of you don't ask!

GRIOT2: I'll ask!

GRIOT3: No, I'll ask!

GRIOT2: No, I'll ask!

GRIOT3: No, I'll ask!!

GRIOT1: Fine! I'll ask! I'll ask!

GRIOT1: HELLO?

AUDIENCE: HELLO!

GRIOT1: Do you want to hear a story?

AUDIENCE: Yeeees!

GRIOT1: Are you sure!

AUDIENCE: Yeessss!

GRIOT1: Are you sure sure!

AUDIENCE: Yessss!

GRIOT1: Arghh! Should we tell them?

GRIOT3: I think we should.

GRIOT2: They came all this way to our planet.

GRIOT3: They're not on Earth anymore.

GRIOT2: They came to our planet.

GRIOT3: They left their own world.

GRIOT2: They came to our planet.

GRIOT3: They walked through our doors.

GRIOT2: They came to our planet!

3

GRIOT1: Okay, of course! Of course!

Take your places.

The storytellers get into position

Lights. Music. 3... 2... 1...

ALL: This is the story of the light that grew a tree, the tree that saved a planet, and a prince who learnt what mattered.

And the moral of this story, which every story needs, is that Small Efforts Matter, Every Little Bit. Small Efforts Matter, Every Little Bit!

GRIOT3: Say that: Small Efforts Matter.

AUDIENCE: Small Efforts Matter!

GRIOT2: Every Little Bit.

AUDIENCE: Every Little Bit!

Beat.

GRIOT1: Once upon a time.

GRIOT2: In the Alkebulan Galaxy

GRIOT3: In the Kanuri Solar System.

4

GRIOT1: In the not too distant past.

GRIOT2: On our planet, like Earth, but much further away.

GRIOT3: There was trouble, our world was not at ease. The temperature was rising, the planet heating up. The rivers, lakes and seas were drying up.

GRIOT2: The fields and farms were without water, so plants and leaves and trees were dying.

GRIOT1: There weren't enough resources to feed all the living things and the people were worried, and the people were scared.

GRIOT2: The Hausa people wanted what was left.

GRIOT2 presents a tribe of people dressed in blue.

GRIOT3: The Fulani people thought they deserved the rest.

GRIOT3 presents a tribe of people dressed in yellow.

GRIOT2: The Sultan of Zekoto was a Hausaman.

GRIOT3: The Sultana, his wife, was Fulani.

SULTAN: "The Hausa will want me to give them everything."

SULTANA: "The Fulani will want me to do that too."

SULTAN: "How can we save our planet and people?"

SULTANA: "What's the right thing to do?"

Beat.

GRIOT1: They had a son, the Little Prince, and the Little
Prince listened as they argued.

GRIOT1 presents LP.

GRIOT2: "We were on this planet first, we ruled for
thousands of years, her natural riches and watery
wealth is ours by land and ours by birth."

GRIOT3: "We saved this planet in the first Galactic War!
They wouldn't be here if it wasn't for us. In the rules
of conquest, to the victor goes the spoils. Everything is
ours, from the water to the soil."

GRIOT2: "Ha! If you want soil, here!"

*A Hausa chief throws a handful of soil at a Fulani chief,
unleashing chaos. The nations clash, then take to their spacecrafts
and a mighty battle ensues among the stars.*

GRIOT1: As the battle raged, from the soil to the stars, the
Sultan and Sultana tried to hide the prince.

SULTAN: "Little Prince go back to your room!"

SULTANA: "The walls are tough and will protect you."

LP: Our nations are fighting! I can be of use! I won't hide in my bedroom!

SULTAN: "Take this vine"

We see the vine in a glass dome.

SULTANA: "It's the last plant alive."

SULTAN: "Guard it, protect it"

SULTANA: "Make sure it survives"

SULTAN: "If our planet crumbles, if all else falls"

SULTANA: "This will revive us, it will save us all."

BOTH: "Whatever happens, the future is yours. You'll do what's right when the time comes."

SULTANA: "Go now Little Prince!"

SULTAN: "Hide until we call."

LP takes the vine and floats to his room. As he talks, the vine shakes and shudders.

LP: There's a battle outside and this vine is very small. Look how tiny it is! It can't do much at all. We need big things to stop the horrid war; a massive magnet to take away their guns? One ocean-planet to restore our shores? One huge fruit that can feed us all? We need big things, this is too small. If natural weather balance is restored, the war will stop. And the future is mine, "The Future is Yours".

Is it up to me to save our world? I'll take it upon myself to fix my whole planet. The answer is out there, I will go and find it.

LP goes to his spaceship. The vine shudders from the turbulence of LP's ship as it takes off.

GRIOT1: The Little Prince planned a galactic course to seven planets that were like his world, to go from our galaxy to the milky way, and finally to your planet called Earth. He took one last look at his planet, and zoomed into the stars.

LP flies into space leaving his family, and most importantly, the vine, behind.

LP lands on a planet.

GRIOT1: On the first planet, the Little Prince met a king, whose halls were lined with animals he killed.

8

WM: I am Supreme Ruler, Your Majesty, The King,
 Commander of Armed Forces and everything you see.

GRIOT1: The Little Prince explained the trouble on his
 planet, he had to restore balance and stop the horrid
 war.

LP: Can you help me, Your Majesty? Anything I can use?
 Our weather is changing, my people are confused. I
 need something big! What can I do?

WM: It's simple Little Prince, you need strong rule. Don't
 listen to the people, tell them what to do! Enforce
 order! That will give you balance! I did that. See
 problems on my world?

LP: You are the only one here, everyone is gone.

WM: Good riddance to all of them, their daughters and
 their sons. When they left I hunted out those that
 disobeyed.

LP: Is that what happened here?

LP gestures to the mounted animals.

WM: That's the price they paid.

9

LP: I can't do that, that is not the way. I can't force people, force pushes them away. You can't help me. I'll be on my way.

WM: Wait! You are my subject! I order you to stay.

LP makes it to his spaceship, but the King Masquerade strips a piece of it away.

Come back Little Prince! This is an outrage!

LP: You destroyed your planet! Grown-ups are very strange.

LP flies off into the stars and lands on another planet.

GRIOT1: The Little Prince landed on another planet, home to one who wished to be admired.

MN: I'm the most handsome, best dressed, intelligent person here. You may now salute me, don't just stand and stare.

LP: Can you help me handsome one? Anything I can use? Our sun is burning us, it's unbearable. I need something big, what can I do?

MN: It's simple Little Prince. This is called a mirror. It's good for looking in to see the full picture. See how handsome I am? See my perfect features?

LP: How can this help me to cool my planet's heat?

MN: They reflect sunlight and can send away the heat.
Get a few big ones, stick them in the sky to bounce
the sunlight back to where ships fly!

LP: Won't they fall down and break to many pieces?

MN: Yes, but you'll have more places to admire my
features.

LP: So you know it won't work. It won't solve anything.
Why should I do it?

MN: Because appearance is everything. People will see
you.

LP: The problem will still be there! I don't think you can
help. I'm going elsewhere.

MN: Wait! Little Prince! Do you like my hair?

*LP runs to his spaceship, but the Conceited Masquerade strips
off another piece.*

Come back Little Prince, stop! This is an outrage!

LP: You only care for looks! Grown-ups are very strange.

LP flies off into the stars and lands on another planet.

GRIOT1: Another planet was completely full of junk,
 home to someone who was always drunk.

DD: This planet was once full of beautiful trees, this
 bottle helps me forget how bad it is.

LP: Can you help me at all? Anything I can use? Our
 forests are failing, farms don't bear fruit. I need
 something big, what can I do?

DD: Drink this Little Prince, this is what I do. It takes
 away my problems and takes away my shame.

LP: What are you ashamed of?

DD: What I didn't do! I could have saved my planet,
 I didn't make a move.

LP: You can still help it! Clear away the junk?

DD: It's too late Little Prince, forget it, let's get drunk!

LP: I do not want any and I don't believe that you can
 help so I am going to leave.

 *LP runs to his spaceship, but the Drunken Masquerade strips
 off another piece.*

DD: Come back Little Prince, stop! This is an outrage!

LP: You gave up so easily! Grown-ups are very strange.

LP flies off into the stars but his spaceship is falling apart.

GRIOT1: As the Prince's spaceship was falling to pieces, he finally saw Earth, the coastlines and the beaches and steered as best he could, with all of his effort, to land in the middle of your Sahara Desert.

LP enters Earth's atmosphere just when the engine fails completely. Instead of an ejector seat, he has an ejector hoverboard. It shoots out of the ship just before it crashes, almost hitting a sunbathing SNAKE.

SNAKE: Arghhh!

The SNAKE slithers away in time. LP hoverboards softly and safely down to the sand.

Act Two

LP flies around looking at various things, a cactus, a scorpion. He spots a PILOT tinkering with her dismantled fighter plane and flies closer, but she is so invested in her work, she doesn't notice him. He gets off the hoverboard, unclips the two discs that make it hover from the underside – it doubles up as an amulet – wears this around his neck, and approaches the PILOT.

LP: Hello! Hi! Hi! Hi! Hi!
 I am the Little Prince
 What is this you have here
 You've got so many things.
 This one here, with big wings?
 Is it a kind of bird?
 Are these all of its eggs?
 What's this and that is weird!

LP picks up two nuclear missiles.

PILOT: Okay, listen, I need you to give those to me
 slowly, sloooowwwwwly, carefully.

LP gives them to the PILOT, who lays them down gently.

Who... what... where... how... why are you here?

LP: Oh! It's a flying craft!
 An old and ancient one.
 Are these its inside parts?
 And are you the airman?

PILOT: Air woman, this is my fighter jet. Don't touch
 anything, I haven't fixed it yet. Everything is laid out
 in a special order, they are where they need to be,
 from the centre to the border.

LP: So your ship is broken?
 Well, I can fix it quick.
 I bet it's this big thing,
 Pass me that metal stick.

PILOT: Leave it! Drop it! Read my lips! This is my
 method and this is my ship. Those are propellers,
 those are the slats, those are the spoilers and those
 are the flaps. They may look randomly laid without
 intent, but if you do this, they turn into a tent.

 As she speaks, the SNAKE slithers around.

 I used the flight panel as a magnifying glass to start
 a fire when the night-cold blasts. And I stripped
 my parachute to make sandbags to protect from
 the snakes, their slither and their fangs. So you see
 Little Prince, they are there for reasons, don't move
 anything! Your hands where I can see them!

Beat.

I don't know if you're really here, or if you'll fade
away but I have a mission and I must be on my way.

*The PILOT returns to work. LP looks round and picks up a
stone.*

LP: Can I ask a question?
 Tell me, what is a snake?
 I don't think I've seen one
 You make them sound unsafe?

The SNAKE circles as they speak.

PILOT: You don't know what a snake is? You're not
 from here are you? They are dangerous slippery
 creatures that don't do any good. They are thin and
 long and crawl across the ground, they'll attack any
 living thing that they see around. They shed their
 skin, they have sharp teeth, they bite and poison,
 don't engage with them, resist!

LP: You make them sound scary.
 They crawl on their belly?
 They don't have any legs?
 Not just one? Not any?

PILOT: They should have grown some like the rest of
 us, they must have given in to gravitational force.

LP: Gravity! It's strong here!
 It's weaker at my home.
 I jump and float high there
 but here I drop like stones.

 LP drops the stone.

PILOT: You don't like gravity?

LP: It's the worst force to combat!
 It holds everything down!

PILOT: Yeah! What is up with that?

 LP laughs.

PILOT: When I was your age, all I wanted was to draw,
 to sketch what I imagined and the ways I saw the
 world. I drew an elephant inside a snake once, but
 the adults couldn't see it. *That's a bad choice! Looks
 like an old hat? You need a proper job!* So I joined the
 airforce, because I wanted to fly, to leave them all
 behind and belong to the sky. There is so much
 freedom!

LP: It's quiet and it's calm!

17

LP & PILOT: You hold the controls and
the world is in your palm!

*LP & the PILOT laugh together. LP laughs longer and the
stars shimmer.*

PILOT: You really *are* a pilot, you're the youngest one
I've seen. You are not from here are you? Tell me
where you've been. Where is your aircraft? Can I
take it for a spin?

*LP doesn't answer. She tickles him, he laughs. The stars
shimmer and the PILOT notices this.*

The stars shimmer when you laugh, you know that
Little Prince?

LP: Who can know everything?
I only know I'm here.

PILOT: Come and sit beside me, are you thirsty? Here…

They drink and sit together.

So where are you from? You have to tell me
something, why did you leave your home? Did you
also draw something?

LP: *(Laughs.)* My planet is troubled
and my people cower,

exhausted, we need food,
we've had no rain-showers.
Our farms are fields of dust.
I left home to scour
the universe for help,
gets worse every hour.

PILOT: Are temperatures rising? Storms getting wilder?
Icebergs melting? Forests on fire?

LP: We've lost all our forests!
And our icebergs are gone.
The heat is still rising.
That's why I have come.

PILOT: You've come to the right place, we have the
same battles. We are trying many things, many
plans, big schemes that'll stop the heat from
strangling our farms.

LP: Can you share some of them?
It's why I left my world.

PILOT: Help another pilot? Of course!

*The PILOT shakes LP's hand, and evokes some of the King
Masquerade as she speaks.*

Right, we have leaders passing new laws, things we
have to do backed by judicial force!

LP: Well, you can't force people,
force will drive them away.
And people aren't robots,
There must be other ways.

*The PILOT evokes some of the Conceited Masquerade as she
speaks.*

PILOT: There are plans to use mirrors, to hang them
in the sky, bounce back the sunlight that doesn't
comply / with

LP: Trust me when I say that
that will not work either.
I stopped by a planet.
They tried that. No differ.

*The PILOT evokes some of the Drunken Masquerade as she
speaks.*

PILOT: I'm thirsty again. I need a good drink? I'm
trying to remember... it might help me think?

LP: Giving up already?
You're trying to get drunk?

PILOT: No /

LP: I've not crossed galaxies
 to stand here by this junk.

LP kicks part of the jet.

PILOT: Hey!

LP: Six planets visited!
 The third had a drunk man
 who gave up! Did nothing!
 I still don't understand.
 He sat there as his world
 became a barren land.

PILOT: Where else did you visit? What did you see?

LP: You really want to know?
 It felt like a dark dream
 I crashed past asteroids
 fell through meteor seas
 And stopped on a planet
 like I had never seen.
 There were reams and reams of
 paper, bursting from bins
 and one wearing a suit
 who counted everything.

21

As he speaks, the Businessman Masquerade takes form from the PILOT's jet's parts, and the scene plays out.

BM: Five hundred and one million, six hundred and twenty-two thousand, seven hundred and thirty-one. Five hundred and one million, six hundred and twenty-two thousand, seven hundred and thirty-two.

LP: Five hundred million what?

BM: Go away, I'm busy, doing important sums that will make you dizzy!

LP: Five hundred million what?

BM: Those tiny things afar. The glittery, shiny, sparkling things.

LP: You are counting stars?

BM: Of course, someone has to! Before they can't be seen. We've lost our natural balance and the clouds will turn to smog and the smog will hide the stars and trap the planet's heat which could burn our farms, our trees, our leaves.

LP: So why are you counting?
Get up! Try and stop it!

BM: Well, I have to know what's out there, I have
 to make a list and calculate the price, the exact
 financial risk of not doing anything, and it's quite a
 bit. This list is of the lakes, that one of the rivers, that
 one of the pools, that one of the mountains, that one
 of mountain views.

LP: How do you decide on
 the price of mountain views?
 What if you don't like it
 And other people do?
 Would you say it's cheaper?
 Others have other views.

BM: I'm a businessman. This is my job. Business rules
 my planet and it will save my world.

LP: But while you're making lists
 your whole planet could burn,
 along with your papers!
 They won't repel the sun.

BM: People won't save the planet if they don't know
 what it costs!

LP: If that's the sole reason
 then it's already lost!
 'Cause some things are priceless,
 they can't have any cost!

I thought you could help me,
but now I don't believe
you care about your world
so I'm going to leave.

*LP runs to his spaceship, but the Businessman Masquerade
strips off another piece.*

BM: Come back Little Prince, stop! This is an outrage!

LP: Focusing on money!
Grown-ups are very strange.

Tell me, is that done here?
Is your planet arranged
or ordered by money?
Because that is deranged!

PILOT: It's very complicated. Let's not discuss that.
You saw two other planets? Tell me about that. Did
anyone help?

LP: I wish I could say that.

*As he speaks, the Lamplighter Masquerade takes form from
the PILOT's jet's parts, and the scene plays out.*

It was the smallest world
no bigger than a camp
and had the saddest man

who stood beside a lamp.
He would light its candle
and then he'd blow it out.

LP: Why are you doing that?

LL: I was given orders.

LP: And what are your orders?

LL: To switch off this lamp.

LP: But you'll be in darkness.

LL: That's why I switch it on.

LP: Why don't you leave it on?

LL: We've lost natural balance, and anything that burns
makes the planet hotter, so I can't leave it on.

LP: Are there not other things
to try to save your world?
Putting candles off and
on, seems to me absurd.

LL: Yes, there are many things, but I have my orders.

LP: What if what you're doing
 won't make anything change.

LL: I've been given orders, I'll do it anyway.

LP: Just doing? Not thinking?
 That is an outrage.
 You can't help me either
 Grown-ups are very strange.

 Tell me, is that done here?
 Is your planet so strange
 that people don't think?
 Because that is deranged!

PILOT: It's very complicated. Let's not discuss that.
 You saw one other planet? Tell me about that. Did
 anyone help?

LP: I wish I could say that.

 *As he speaks, the Geographer Masquerade takes form from
 the PILOT's jet's parts, and the scene plays out.*

 It was the biggest world,
 ten times as big, so huge,
 and there, a geographer,
 sat on a tiny stool,
 before a massive desk
 which held a massive book.

The biggest things! I thought.
Help must be here! Just look!

A geographer you say?
What is it that you do?

G: I note the locations
 of mountains, deserts, seas,
 rivers and the cities,
 then draw where each one is.

LP: D'you have oceans?

G: I don't know for sure.

LP: But you're a geographer.

G: I note, I don't explore. We lost our natural balance.
 It changed our whole world so what is on my books
 might not be on the shores.

LP: So why don't you go check?

G: Because it's not my job. I wait for those like you who
 go out to explore, to come with information, with
 proof, and then I draw.

LP: What kind of proof d'you need?

G: Well, proof of a mountain would be a few big rocks.
Proof of a sea-town, pictures of loading docks. But
tell me of your planet, I'll find a pen that works.

The GEOGRAPHER finds one and takes notes as LP speaks.

LP: Well we have huge mountains
deserts wider than seas,
a vine I was given,
and we used to have trees.

G: Oh don't bother with vines and don't bother with
trees.

LP: Why not?

G: They are ephemeral.

LP: I don't know what that means.

G: It means in danger of early disappearance.
Mountains last for ever, vines might last a week.

LP: My vine might disappear?

G: If it isn't cared for and has nothing to drink, it will
turn to dust, like every living thing.

LP: I left it back at home
 alone on the planet!
 It was mine to care for
 yet here I am, stranded.

 And you cannot help me
 if you just sit and draw.
 Your whole world is out there
 there are planets at war
 and you won't even stand
 to see the closest shore!

 You're silly and useless.
 You're making me outraged!
 You can't help me either!
 Grown-ups are very strange.

 Tell me, is that done here?
 Is your planet so strange?
 Where people do nothing?
 Because that is deranged!

PILOT: I...

LP: Yes?

PILOT: I...

LP: Is you planet like that?
 Where people are so strange?

PILOT: Our planet is just like that, and we have the
full range; people who do nothing, just sit buried in
books, others that don't think, just do what they're
told, lots of business people wanting to get rich,
others who are hopeless, who wake up to drink,
some who look very good, but don't do very much,
some who are in power but don't really give a ff…
care how they treat us, we have them all here.

LP: Well that is just brilliant!
What On Earth should I do?
Wallahi Tallahai!
I am the biggest fool!
I'm a foolish silly
Hausa-Fulani boy.
I left my home planet
hoping to save my world
and can't even find one
that isn't more absurd.
Foolish, silly, Hausa-Fulani boy.

*As LP speaks, he kicks, trashing the PILOT's perfectly arranged
items.*

Foolish, silly, Hausa-Fulani boy.
Foolish, silly, Hausa-Fulani boy.

PILOT: Stop! Stop! Stop! Stop!

LP grabs one end of the metal piping, the PILOT grabs the other end. They pull, yelling angrily at each other. The piping slips from the PILOT's grip. LP falls back and hits his head on a rock.

LP: Yey! Ow!

PILOT: Little Prince, are you okay?

LP: If you dare touch me! No!
 No! No! Back away! Stand!
 You are not Zekotan!
 You'll never understand!
 You're not from my mother
 or from my fatherland.
 You are nothing to me
 less than a grain of sand.

PILOT: Fine! Go! Get away from my camp. I'm sorry I
 can't help you, but I won't just stand and be insulted
 by a little alien brat. I have a mission, and I must
 complete that!

LP: I hope you are stranded
 and your ship never works!

PILOT: I hope *you* are stranded
 and *your* ship never works!

LP unclips his amulet, remakes his hoverboard and skates into the desert, angry and upset.

The PILOT turns to survey her mess, angry and upset.

LP goes deep into the desert, growing tired as he walks.

GRIOT1: The Little Prince was so upset, he skated into the desert. He didn't know where he was, and didn't know what he'd see but the Pilot had so angered him, he didn't care a bit, just as long he wasn't there and she wasn't close to him.

GRIOT2: Meanwhile in Zekoto, the battle was raging on. The Sultan and Sultana ran through the halls calling for the Little Prince, they didn't know he'd gone.

GRIOT3: He was all alone, just himself and desert stones. And just when he grew tired, a little frightened of your world, he met one of your animals, a playful desert fox.

At first, LP is frightened of the FOX, but they begin to play, chasing each other around sand dunes. When it is LP's final turn to chase, FOX runs off into a secret garden of vines and roses. LP follows, astounded that such a thing exists in the desert.

LP: A garden? A forest?
 How on Earth is this here?
 There's no natural balance,
 and deserts blow hot air!
 This is impossible!
 It's not real. It's not here.

FOX: Believe what you want my boy, but that bush has
 real thorns, those are real flowers, and those vines
 are tough as horns.

 LP tugs at one.

LP: Wow

FOX: Real enough my boy?

LP: They're as real as my vine,
 the one I left at home
 but how did this get here?
 plant life can't grow from stones!
 There's no flowing water,
 the sand is dry as bone.

 Wait. Did you do this? You?
 You did this? On your own?

FOX: We foxes are cunning. We know more than we show.

LP: Help me save my planet!
 I need to make plants grow,
 restore natural balance
 and stop the war, so show
 me how you did this please?
 Please tell me how to grow.

FOX: I'll give you three guesses!

LP: It came from a planet
 of superseeds that grow?

FOX: No.

LP: Large mirrors in the sky
 that keep temperatures low?

FOX: No.

LP: You hacked plant DNA,
 uploaded new grow codes?

FOX: *(Laughing.)* No!

LP: Tell me how you did this.
 And don't just tell, but show.

FOX: Well, it's simple really. In the desert, there's a well.
 Miles and miles from here, across dunes and valleys,

rocks and boulders. I'd wake up in the morning,
walk all the way there, fill my cheeks with water,
walk back and pour it here.

LP: A mouthful of water?
 Across all of those miles?
 To grow a whole garden?
 It must have taken time?

FOX: Hundreds of journeys, thousands of watersips,
 all the animals laughed. *That fox is a bit thick! It will
 take him ages*. It did, but bit by bit, it grew into this
 garden, this paradise you see. Here's the thing my
 boy, if you are small, so can't do the big things, it's
 okay, rather, focus on the small things, for Small
 Efforts Matter.

LP: Focus on the small things,
 for Small Efforts Matter.

FOX: Small Efforts count.

LP: Even as small as seeds?

FOX: As small as vines and weeds, they're the most
 precious things.

 *LP touches the vines and flowers in awe and thinks of his vine
 at home on his planet.*

I bet you wonder how I knew, that my plan would make them bloom, with so many plans I tried before, between the two of us, I once gave up. It took me by surprise I must say, I found out in such a simple way...

The FOX whispers to LP.

I heard it from the small vine. *Don't You Rush* it said, *Take Time.* I heard it from the small vine, when I was just about to lose my mind, it said *Take Your Time.*

LP: I now know what to do
and how to save my home.
The Small Efforts Matter!
Oh! How did I not know?
I have to leave right now!
But what's the way to go?

FOX: It's been a long day, and night is almost here. Just wait until the morning. It's sleep time now, rest here.

LP curls into the FOX. As they sleep, the blue light of Zekotan tech glows, grows out of LP's amulet, into the garden, listening and learning from the plants. The light turns green then flows back to the amulet. At dawn, LP wakes up.

LP: Good Morning. Are you up?
I have to save my world.

FOX: Good luck Little Prince. Remember, focus on the
 small things, for Small Efforts Matter.

LP: Yes, Small Efforts count!

FOX: Small Efforts mean a little dedication achieves
 fantastic things. Good luck my prince, good luck and
 save your world.

LP: Thank you for your wisdom,
 and thank you for your words!
 They'll help save my planet,
 farewell my clever fox.

*LP waves, wanders off into the desert and we see the SNAKE
following. LP is unsure of which direction to go and almost
steps on the SNAKE.*

SNAKE: Ouch!

LP: Sorry! I didn't see you,
 entirely my mistake,
 never met one like you...
 Oh wait, are you a snake?

SNAKE: Sensational to meet you, simply stupendous.

LP: Is it true you shed skin
 and have really sharp teeth?

SNAKE: Correct, precise, you're right, affirmative.

LP: She told me don't engage
 with you. I am to resist.

SNAKE: Who told you that?

LP: The Pilot. You seen her?
 I don't think she has flown.
 We're lost in this desert
 trying to get back home.

SNAKE: Well, I can take you farther than any ship can
 roam, a special touch of mine sends things back to
 where they're from.

LP: Can you do all of that?
 No region is too far?
 You can help me get home?
 Even from where we are?

SNAKE: Absolutely, positively, to any place and space.
 Tell me where you're from. You don't have any snakes?

LP: It's a long way from here
 and my people cower;
 exhausted, we need food,
 we've had no rain-showers.
 Our farms are fields of dust,

I left home to scour
the universe for help,
gets worse every hour.
I left my little vine.
I'm worried about her.
Gravity is so strong
my ship is in tatters,
don't know how I'll leave Earth,
and my hope is shattered.

SNAKE: When you want to go, no matter how far, I'll
get you back home, right from where you are. Do
you know where it is? It can't be very far?

LP: Do I know where it is?
I know exactly where!
Give me space now, move back...
further... Sit over there.

*The SNAKE moves back, the PRINCE takes off his amulet,
places it on the ground and taps it. Instantly there is a light
and sound display of the galaxy and universe all around them.*

SNAKE: Woah! So beautiful! So many stars! Can you
find your planet? The stars are in the way!

LP: Whenever I look up,
even if I can't see,

for stars hide my planet,
all are beautiful to me.

LP zooms in on his planet.

Now, this is my planet
this is my humble home
and these are my parents.

LP zooms out.

Oh! The battles have grown.

LP zooms out.

See, this trajectory
means it will be here soon!
In just a few hours
up there, beside Earth's moon.
I can't miss it.

SNAKE: I promise you you won't. A small effort from
me will send you home, you'll see. Good luck
finding the Pilot, and signal when you need.

*LP waves, wanders off into the desert and finds the PILOT. A
sandstorm had struck. Everything is in chaos. The PILOT is
too distraught to say anything.*

LP: What happened? You okay?

PILOT: DON'T TOUCH ANYTHING! First you, then
a sandstorm brought chaos to my order, everything is
upside down! I don't know what is worse, you or the
storm! Just leave me alone! Leave me on my own!

Act Three

LP sits down and fiddles with his amulet. He accidentally tunes into a radio station playing one of the PILOT's favourite songs, Marvin Gaye's 'Heard it through the Grapevine'. The PILOT can't help herself dancing, she cheers up and dances with LP. When the song fades, she is happier.

PILOT: I'm really sorry I yelled at you. I should not
　　　have done that.

LP: We all go through tough times.
　　It's fine, I'm not upset,
　　but I have some good news.
　　I can now fix your jet.

LP charges around upturning things, causing more chaos and trying to lift things bigger than he is.

PILOT: Stop! Stop! STOP! You'll hurt yourself carrying
　　　on like that! Why don't we think this through?
　　　Come, stand back. Okay, I'll lift the big things, you
　　　bring the small things scattered?

LP: I'm happy to do that
　　for Small Efforts Matter!

LP and the PILOT put the jet back together.

PILOT: Okay, there!

LP: Go on, start the engine.

> *The PILOT tries the engine, it stutters and splutters, belches smoke, and doesn't work.*

PILOT: It's hopeless. I'll never fly again.

LP: Just trust me. Small Efforts.
Small movements and small ways.

> *LP presses his amulet to the jet and listens through it, to the engine in deathly silence.*

> *He taps the amulet and a clean neon green light grows and glows out of it into the engine, suggesting its change to clean energy.*

> *LP then stands back.*

LP: There. Now try it again.

> *The jet hums into life. The PILOT turns the engine off, jumps out and hugs LP.*

PILOT: Thank you so much! You have saved my life.
But how did you know?

LP: Heard it through the grapevine!

They laugh. As the PILOT hugs LP, LP signals to the SNAKE, who slithers up and bites his ankle. The world flickers and shimmers in yellow, blue, green and gold, the wind rises and swirls around them.

PILOT: Little Prince? Little Prince! Oh no! No! Don't go. Hang on! Don't leave me on my own.

LP: Stop crying, it's okay.
Shh. This is my way home.
This body, so heavy,
it weighs so many stones,
to get to my planet
I must leave it alone.
I'll become a small thing
but now I really know
that small things do matter
they make the big things grow!
Don't let Earth get battered
and natural balance go,
if you all did small things
all of you, every soul,
you could save your planet!
It's now my time to go.
Goodbye my pilot. Save
your planet. Save your home.

LP goes limp.

The PILOT lays LP down gently.

A small blue light leaves his body and flies into space, closely followed by the amulet.

The light and amulet re-enter the Kanuri solar system and reach planet Zekoto. The war is still raging. They dodge laser beams to LP's home.

The SULTAN and SULTANA watch his light return, and know what it means.

SULTAN: "Our Little Prince's light, has returned to our world."

SULTANA: "We will never forget his warmth, how he lived, how he hugged."

They mourn him.

SULTAN: "I heard his voice, pulsing in my dreams."

SULTANA: "I heard it too. I think he was singing?"

SULTAN: "Small Efforts Matter, Every Little Thing. I heard it too! What does it mean?"

SULTANA: "It means: Do what you can."

SULTAN: "Even if it's hopeless?"

SULTANA: "Especially when it is."

SULTAN: "Small Efforts Matter"

SULTANA: "Every Little Thing!"

With small efforts, the blue light topples the glass dome around the vine. The blue flies into the amulet, turns green, then flies into the vine.

GRIOT2: The Sultan of Zekoto gathered the Hausa People.

GRIOT3: The Sultana of Zekoto called the Fulani.

GRIOT1: They taught the phrase to the kingdom, the Kanuri Solar system, their whole galaxy.

SULTAN: "Small Efforts Matter…"

SULTANA: "Small Efforts mean…"

SULTAN: "A little dedication…"

SULTANA: "Achieves fantastic things!"

Before the people, the vine blooms into a massive baobab tree and restores natural balance to the planet.

GRIOT1: And so it came to pass that natural balance was restored. The trees cleaned the air, the temperature cooled, the rivers, the lakes, the ponds and all the pools swelled with precious waters and the farms grew foods anew. Small Efforts! Little Things! And back on Earth, the Pilot agreed…

The PILOT is knelt by a small mound where LP's body is buried. There is a small flag saying 'lp woz ere' stuck in the ground.

PILOT: A thousand Small Efforts, I promise you my prince! I have a new mission, I'll start making a list of all I need to do, and I'll do all of it. I'll go into the world, I'll try to change what's wrong, if it seems big and difficult, I'll just start small.

The PILOT starts her engine and takes off.

ALL: This is the story of the light that grew a tree, the tree that saved a planet, and a prince who learnt what mattered.

And the moral of this story, which every story needs, is that Small Efforts Matter, Every Little Bit. Small Efforts Matter, Every Little Bit!

Song and dance.

THE END.

WWW.OBERONBOOKS.COM

Follow us on Twitter @oberonbooks
& Facebook @OberonBooksLondon

9 781786 828705